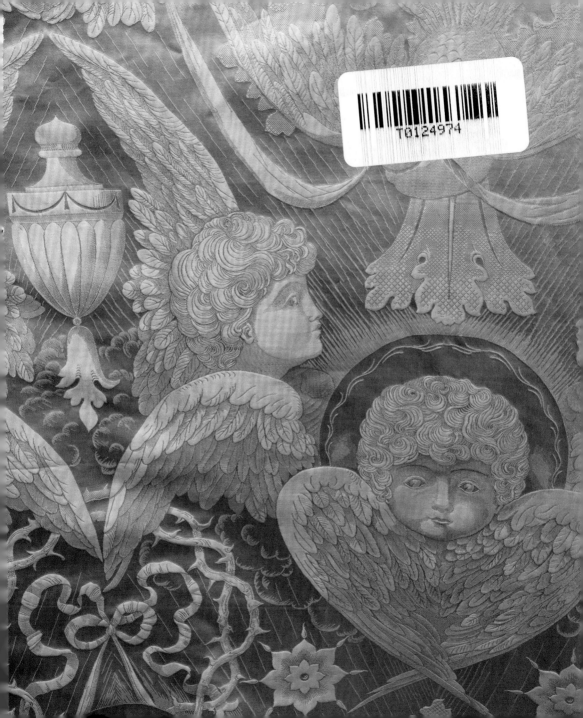

...nbuſ. ta anobiſ er
...menaſ egreſſu do?
...mo dubitaret an
...bi cum ſco gene
...aſ mali impeta
...bantur interî
...ſetanda nati
...buſ falera
...enteſ na
...ra tacta
...iſ inter
...e mar
...o
...ul

IVVENIS TEMPORIBVS Q DA?

...abditam regiſ nomine aure
...liuſ apud cordubam hiſpanie
...ciutate. natalibuſ & m...
...iſan...

TREASURES AT
CANTERBURY
CATHEDRAL

SCALA

Introduction

Canterbury Cathedral is the mother church of the Anglican Communion and the seat of the Archbishop of Canterbury. It is part of a UNESCO World Heritage Site, its Precincts have Scheduled Ancient Monument status and the Cathedral is Grade I listed.

It draws together 1400 years of history and over 1000 years of architecture and art, focused around faith and worship. From the time of St Augustine's arrival in Kent in 597, when he established his seat, or 'cathedra', here as the first Archbishop of Canterbury, the site has been central to the Christian Church in England. It is a place of prayer and devotion, of peace and faith. However, there have also been times when it was a focus for dispute and destruction, and even the scene of murder, when Thomas Becket was killed here in 1170.

The outstanding architecture and medieval stained glass are world famous, but within the Cathedral buildings there are also more than half a million collection items, including manuscripts, rare books, textiles, church plate, fragments of architectural stone, and many other historic religious and secular artefacts. The oldest – documents recording gifts of land – date to the eighth and ninth centuries and were made long before the current Cathedral buildings existed. The Cathedral's pre-Reformation archive is now part of the UNESCO UK Memory of the World Register.

The items in Canterbury Cathedral's collections complement the heritage of the buildings and through them we can construct a stronger narrative of the history of the Cathedral and its role in national and international events. The life of each object, from the journey of a papal instruction from Rome, to the manufacture of a textile in the Middle East and its subsequent use as a cathedral vestment, tangibly links the Cathedral's story to a wider world history. Like the buildings, it is important that the objects are seen, interpreted and understood.

The installation of a series of new permanent exhibitions at Canterbury Cathedral was completed as part of The Canterbury Journey, a multimillion-pound conservation and engagement project supported by the National Lottery Heritage Fund, the Friends of Canterbury Cathedral and other generous benefactors. These exhibitions have brought many of the Cathedral's object collections to the fore for the first time, giving the public access to them and the opportunity to get close to these remarkable treasures.

Each object has been carefully selected for display, studied and where necessary conserved. Each one represents something or someone important to the Cathedral's past. Within this book we explore a small number of them: you will find information about twelfth-century vestments and the archbishop who wore them; later Anglo-Saxon and medieval charters; early modern books; and the fourteenth-century Black Prince's funerary achievements.[1]

Yet, it must be remembered that, unlike museums, which contain historic and prehistoric artefacts that are clearly defined as such, the Cathedral houses some material that is historic while also remaining part of the religious services and day-to-day running of the Cathedral. This means that many items, for example Archbishop Lang's early twentieth-century cope, are still used in church services rather than being kept behind glass. As such, each time this cope is worn it accrues new meaning and significance. By the nature of their use, the artefacts and items in the collections of Canterbury Cathedral continually add to their own history. These collections are not static. We hope this book offers a brief introduction to the astonishing and surprising character of some of our great treasures.

Unless otherwise stated, all objects are from the Cathedral's own collections.

Visitor Centre Exhibition

'The delicate accuracy of Mr Gorringe's art positively revels in the minute, and evades the casual scrutiny of ordinary eyesight' (Edward Oakeley, c.1900s)[2]

Twenty-eight nineteenth-century models of British and European cathedrals provide a miniature architectural tour of cathedral design. They were created in the 1850s by a model maker called William Gorringe, but virtually nothing is known about him. The models are made from cardboard and wood and they are to scale, with 1 inch representing 60 feet (2.5 cm to 18.3 m). It is believed that originally there would have been more than 28 in the set, but the exact number is not known. Three are shown here.

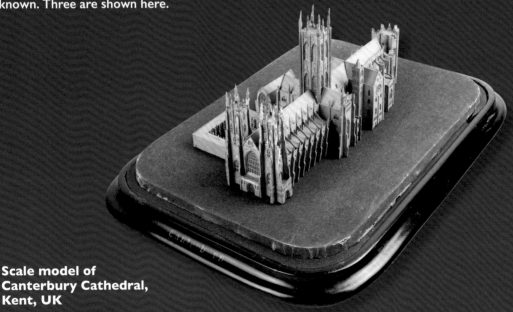

**Scale model of
Canterbury Cathedral,
Kent, UK**

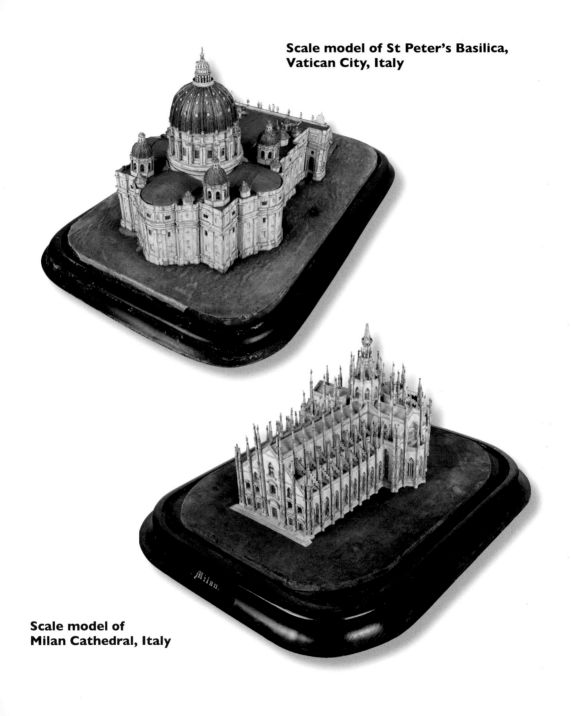

Scale model of St Peter's Basilica, Vatican City, Italy

Scale model of Milan Cathedral, Italy

Milan.

Crypt Exhibition

Many objects in the collections illustrate the national and international impact of Church–State relations on the Cathedral and how they have changed and developed over the centuries.

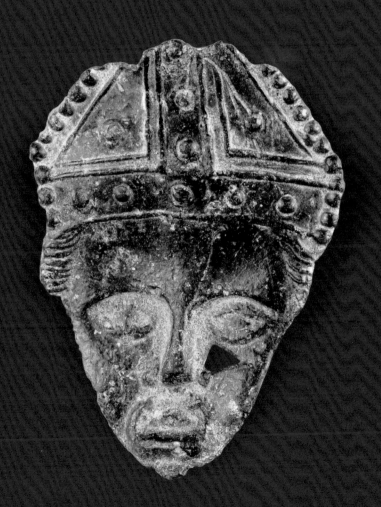

The Birth of the Cathedral

From the time of St Augustine's arrival in Kent in 597 to reintroduce Christianity in the Anglo-Saxon kingdoms, to the establishment of Norman rule in the eleventh and twelfth centuries, there were many changes and disruptions to the Church and to the Cathedral. The objects depicted in the following pages represent the Church's response to threats from secular authorities in the ninth century and offer a glimpse of the Cathedral as it was rebuilt after the Viking raids of the eleventh century. They also illustrate the remodelling of both the Cathedral buildings and religious practice, brought about by the Norman Conquest and progressed by the first Archbishops of Canterbury of the Norman period, Lanfranc (1070–89) and Anselm (1093–1109), and their successors.

Grant from Offa, King of Mercia
788

The oldest document in the Cathedral's collections, this predates all surviving Cathedral buildings. It records a gift of land in Kent to a royal official, Osberht. Due to severe historical damage, some of the text is only visible under ultraviolet light.

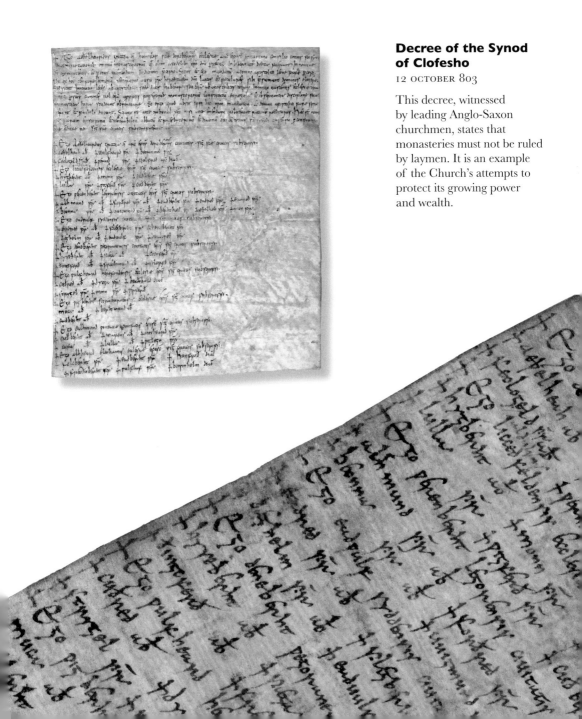

Decree of the Synod of Clofesho

12 OCTOBER 803

This decree, witnessed by leading Anglo-Saxon churchmen, states that monasteries must not be ruled by laymen. It is an example of the Church's attempts to protect its growing power and wealth.

SEAL BAGS

The Cathedral has a significant collection of silk fragments dating from the tenth to the fourteenth centuries. The silks come from all across the known medieval world, but none are from Britain.[3] Probably originally employed as rich hangings or vestments, these fragments survived because, once they were no longer in fashion or were worn out, the silks were cut up and reused as covers to protect wax seals on documents. The earliest examples may have been used in the last Anglo-Saxon Cathedral, which had been rebuilt after the Viking attacks of 1011. They are among the few remaining objects that signify the wealth and grandeur of that building.

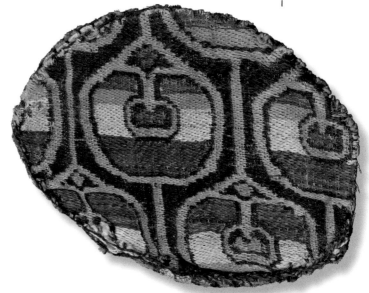

1

1. Seal Bag
9TH–11TH CENTURY

The oldest textile in the Cathedral collections, this silk is from the Byzantine Empire. It was made into this small bag lined with high-quality linen.[4]

2. Seal Bag
10TH–11TH CENTURY

These silk fragments are from a bag that was taken apart about a hundred years ago. They have an unusual design and are probably from the Middle East.[5]

2

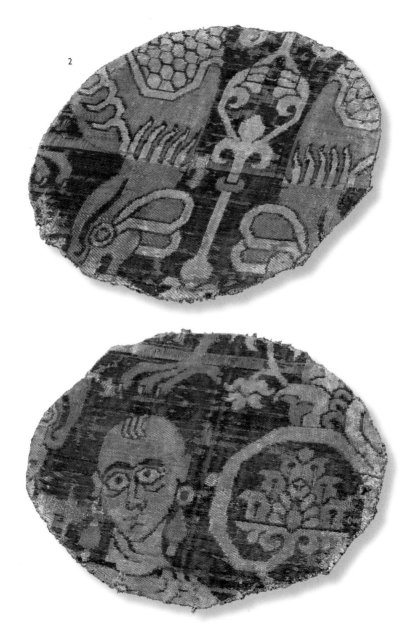

Anglo-Saxon Tiles

10TH–11TH CENTURY

These floor tiles are from the Anglo-Saxon Cathedral. Found in the 1990s during excavations in the nave, they were located in a layer of rubble associated with Lanfranc's demolition of the Anglo-Saxon Cathedral in the 1070s.[6]

The Accord of Winchester

1072

This document confirms Lanfranc, Archbishop of Canterbury, as the leader of the English Church. It is signed with crosses by King William I ('the Conqueror'), his wife Matilda, Lanfranc and other important churchmen (see detail on pages 4 and 5).

Carved Stone Fragment

11TH–12TH CENTURY

This carved beast probably
came from the top of a tower.
It was part of a rebuilding
programme started by Lanfranc
that continued throughout the
twelfth century. It was removed
during restoration in the early
twentieth century.

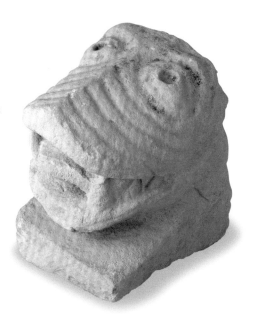

Seal of Anselm, Archbishop of Canterbury

1095–1107

Medieval seals authenticate
documents. This is one of the
earliest surviving English seals
of a bishop or archbishop.
It is made from beeswax.
Anselm is depicted in his
archbishop's vestments, holding
a crozier (the staff carried by
archbishops, bishops and some
abbots as a symbol of their role)
in his right hand, while giving a
blessing and holding a book in
his left. The seal authenticates
a grant of land to one William
Calvellus. It may have been
written in Canterbury.

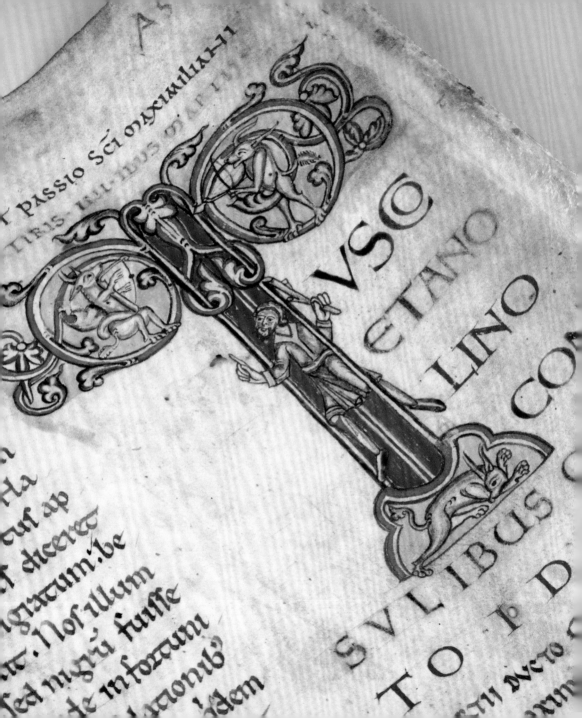

VSO

ETANO

LINO

CO

BVS

Ha

euf ap

et eteetea

gnatum·be

Nof illum

fed m̄gru fuiffe

de infoutim

idem

SVLIBUS

TO P D

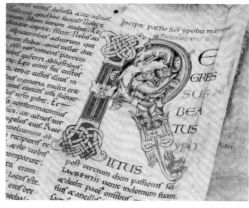

Canterbury Passional

EARLY 12TH CENTURY

These fragments are from a book about the lives of the saints. It was made at Canterbury and its illustrations are similar to carvings in the Western Crypt of the Cathedral, created around the same time. Dismantled during the Reformation, it survived only as pieces in book bindings.

Carved Stone Fragments

LATE 12TH CENTURY

These carvings were made as part of the twelfth-century rebuilding programme. A number of them were discovered in the later Cloister buildings, where they had been used as infill.

Archbishops and Kings

The struggles between Archbishops of Canterbury and medieval kings often involved the Cathedral and its monastic community (Christ Church Priory). Notable events took place in the late twelfth and early thirteenth centuries.

Firstly, there was the dispute in the 1160s between Archbishop Thomas Becket and King Henry II over the rights of the Church that resulted in Becket's murder by four of Henry's knights in 1170. Becket was later declared a saint and thousands of pilgrims flocked to Canterbury each year, first to his tomb and after 1220 to his shrine, hoping for a miracle. Secondly, there was a disagreement in the early 1200s between Pope Innocent III, King John and the Church in England over who should be Archbishop of Canterbury. This resulted in the exile of Canterbury's monks and England being put under an Interdict, that is, forbidden to hold church services.

In contrast, between 1193 and 1205 Archbishop Hubert Walter worked effectively with two successive kings, Richard I and King John. His association with the monks of Christ Church, Canterbury, however, was occasionally difficult, as the monks sometimes felt that the Archbishop was eroding their importance, their privileges and their rights, including the right to elect future Archbishops of Canterbury.

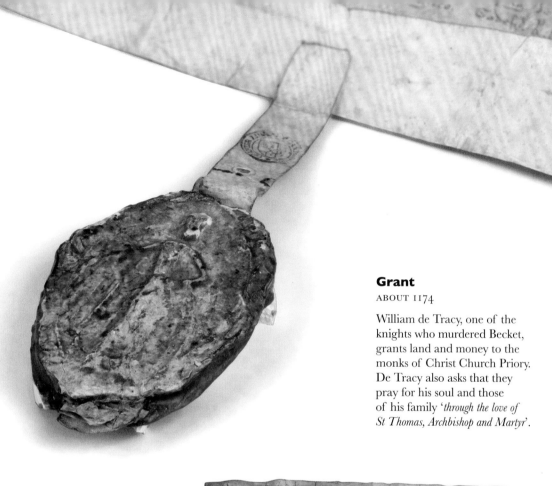

Grant

ABOUT 1174

William de Tracy, one of the knights who murdered Becket, grants land and money to the monks of Christ Church Priory. De Tracy also asks that they pray for his soul and those of his family '*through the love of St Thomas, Archbishop and Martyr*'.

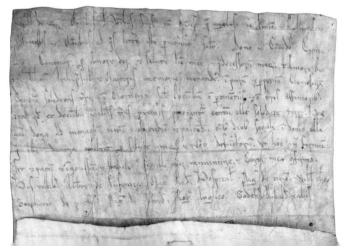

Writ from Henry II

ABOUT 1175

This document, which carries King Henry II's seal, confirms the possessions and authority of Canterbury Cathedral's monastery. It was written soon after Becket was made a saint in 1173 and is believed to be associated with the King's efforts to show repentance for Becket's murder.

Shrine Fragments

ABOUT 1220

These small marble fragments are thought to be part of the stone base of Becket's jewel-encrusted shrine. Built to house Becket's bones and placed in the centre of the Trinity Chapel within the Cathedral, the shrine was destroyed in 1538 during the Reformation.

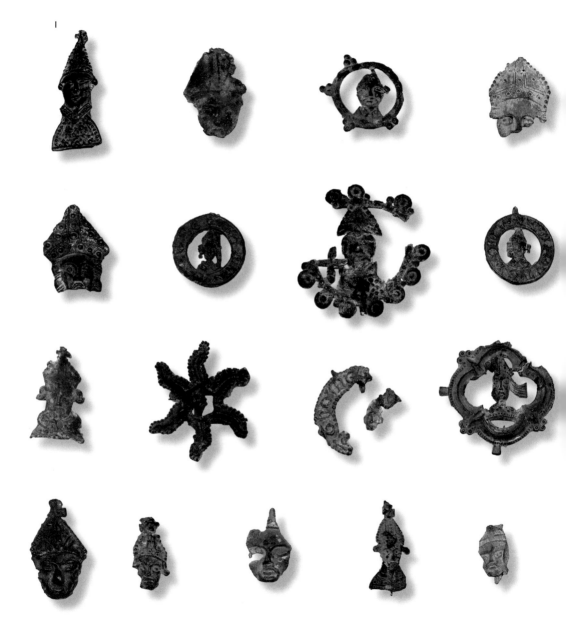

PILGRIM BADGES

Small lead-alloy badges (on average 3 cm tall) were sold as cheap souvenirs to pilgrims outside the Cathedral. Pilgrims pinned the badges to their hats or cloaks as mementoes of their visit to Becket's shrine.

Head badge on page 9 on loan from Mr James Ward

1. Becket Head Badges

14TH–15TH CENTURY

The head design was perhaps the most popular of all the Becket pilgrim badges.

On loan from Canterbury Museums & Galleries

2. Murder of an Archbishop

14TH–15TH CENTURY

Originally believed to depict Becket, it has been suggested that this badge may in fact show a later Canterbury archbishop, Simon Sudbury. It deliberately imitates the imagery used in examples that show Becket's murder. The association between this badge and famous Becket designs reflects Becket's authority and saintliness onto the other archbishop, emphasising the power of Becket the saint. At 7.3 cm it is bigger than the head badges shown opposite. It was discovered on the Thames foreshore in London.[7]

On loan from Mr Corneliu Thira

2

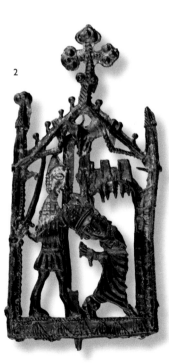

HUBERT WALTER'S FUNERARY VESTMENTS

MID- TO LATE 12TH–EARLY 13TH CENTURY

Hubert Walter, Archbishop of Canterbury from 1193 to 1205, was buried in the most prestigious position in the Cathedral, near to Becket's shrine in the Trinity Chapel. His tomb, made of Purbeck marble, has a very striking design.

When the tomb was opened by the Victorians in 1890, Archbishop Walter was found to be wearing a magnificent set of vestments (clerical robes), with his crozier and a chalice and paten beside him. While all the linen from the vestments had perished, the beautiful silks remained.[8] These silks are probably from an Islamic centre of production in Spain or Iberia,[9] and are covered with designs of birds and animals as well as trees and flowers. Originally in bright greens, reds and possibly creams, many of the vestments are embroidered with gold thread, early examples of 'Opus Anglicanum', a type of fine English embroidery that became famous across medieval Europe. The slippers are studded with garnets.

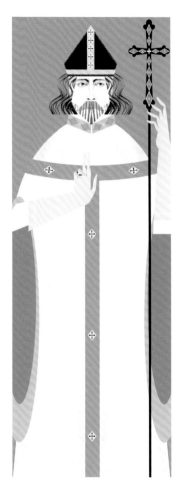

Artistic representation of Hubert Walter in his vestments.

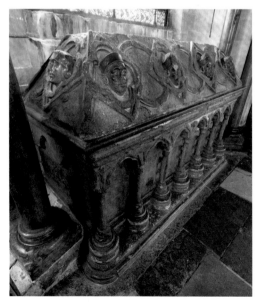

Tomb of Archbishop Hubert Walter (died 1205).

Mitre

Although plain, this mitre is made from rich silk. It is in the shape adopted in England in the late twelfth century, which is still used for mitres today.

Stole Fragments

The stole is a long, narrow strip of cloth similar to a neck scarf, extending to just above the ankle. This example is decorated with geometric patterns, originally in bright reds, yellows and greens.

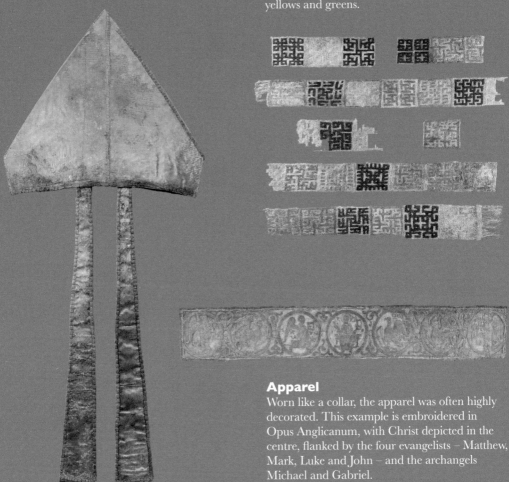

Apparel

Worn like a collar, the apparel was often highly decorated. This example is embroidered in Opus Anglicanum, with Christ depicted in the centre, flanked by the four evangelists – Matthew, Mark, Luke and John – and the archangels Michael and Gabriel.

Alb Apparel and Alb Wrist Bands

The alb is a white linen tunic worn under more ornate garments; the example from Archbishop Walter's tomb had rotted away, but these elaborate silk bands from the wrists and hem of the garment remained.

Chasuble Fragment

This silk fragment is from the lower part of the front of a chasuble, the outermost vestment worn by clergy when celebrating the Mass. The designs on the silk are very similar to those on the dalmatic (see opposite), but smaller.

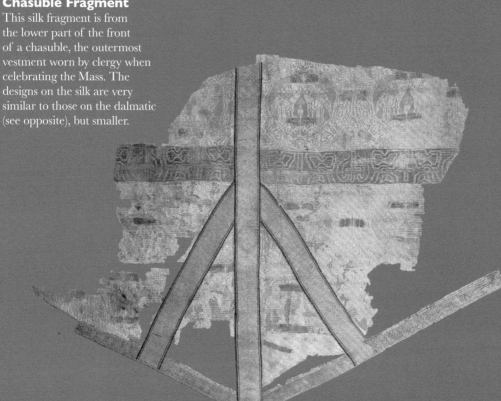

Dalmatic Fragment

This silk fragment formed part of Archbishop Walter's dalmatic, a shin-length tunic with sleeves, worn under (and mostly concealed by) a chasuble. The dalmatic was often decorated with large dramatic designs, as can be seen in this piece.

Pallium Pins

Made from silver gilt, these flower-headed pins (11.5 cm long) would have attached Archbishop Walter's woollen pallium to his vestments at the shoulders. A pallium was a narrow white Y-shaped band worn by archbishops as a sign of their status.

Buskins

These buskins (stockings) are made from green silk and are embroidered with gold thread. Buskins were worn by archbishops and bishops.

Crozier

This simple wooden crozier, studded with four carved stones, was placed across Archbishop Walter's body, with the top resting against his left shoulder.

Slippers

These green silk slippers (or sandals) are lined with amber silk, have red silk soles and are embroidered with gold thread and studded with garnets. They equate approximately to a modern shoe size seven. Slippers like these were usually worn by archbishops for special services in the Cathedral.

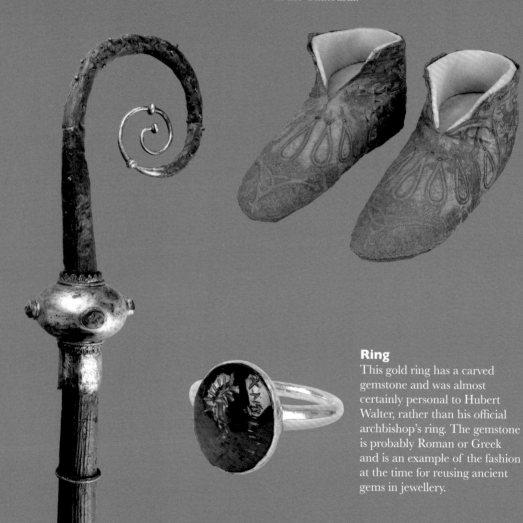

Ring

This gold ring has a carved gemstone and was almost certainly personal to Hubert Walter, rather than his official archbishop's ring. The gemstone is probably Roman or Greek and is an example of the fashion at the time for reusing ancient gems in jewellery.

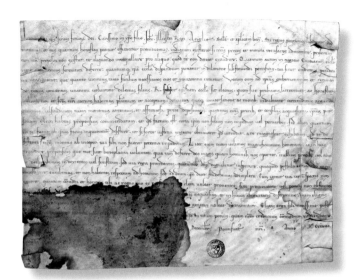

Mandate from Pope Innocent III

DECEMBER 1205

This instruction from the Pope ordered King John to accept Reginald, a senior monk from Christ Church Priory, as elected Archbishop of Canterbury. The King refused as he wanted his own choice, John de Gray. The Pope later rejected both candidates and appointed Stephen Langton as archbishop instead.

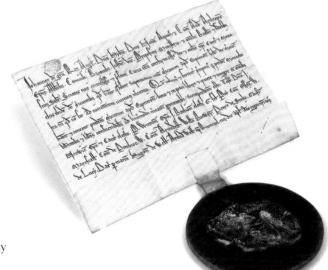

Grant frm King John

4 APRIL 1206

This grant authorises a weekly market at Orpington, near London. In the list of witnesses, John de Gray is named *'Archbishop-elect of Canterbury'*.

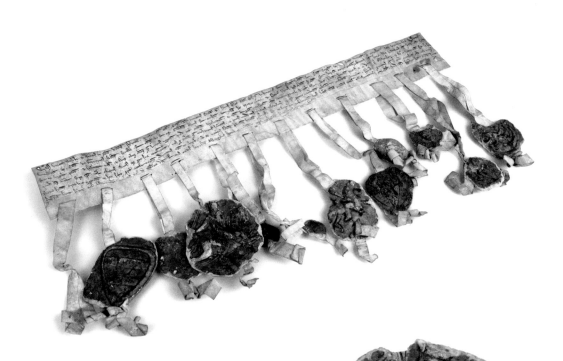

Guarantee

24 MAY 1213

Sent from 12 of King John's loyal barons to the monks of Christ Church Priory, this document guarantees the monks' safety if they return from exile. The barons promise that they will make the King observe the settlement that ended his dispute with the English Church and Pope Innocent III. The document was authenticated by the 12 seals of these barons. The seals are made from beeswax and are attached with parchment tags. One of the seals is missing, but its tag remains.

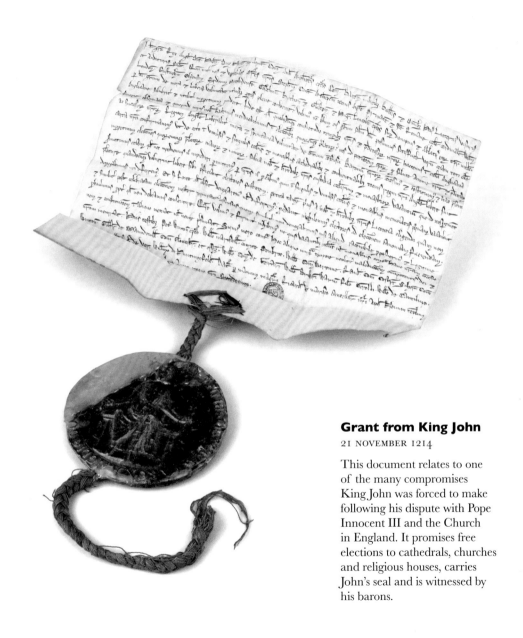

Grant from King John

21 NOVEMBER 1214

This document relates to one of the many compromises King John was forced to make following his dispute with Pope Innocent III and the Church in England. It promises free elections to cathedrals, churches and religious houses, carries John's seal and is witnessed by his barons.

Reformation, War and Resolution

In the 1530s King Henry VIII rejected papal authority and appointed himself Supreme Head of the English Church. Religious practices were reformed and English monasteries destroyed. Christ Church Priory was closed in 1540 and a Dean and Chapter of Canons was introduced to run Canterbury Cathedral.

During the English Civil Wars (1642–51) between Parliament and King Charles I, many church treasures were destroyed. This destruction was led by those known as 'Puritans', who opposed the King. They intended to 'purify' the English Church, creating plain places for worship.

Today, two acts of worship best represent the now settled and supportive relationship between Church and State. In Westminster Abbey, the Archbishop of Canterbury crowns the new king or queen. At Canterbury Cathedral, the Archbishop is enthroned at a service beginning with the reading of an instruction from the monarch.

The Great Bible
1539

A first edition of the earliest official English translation of the Bible, its name is derived from its size (this copy is 40.5 cm high by 28.3 cm wide and 11.1 cm deep). Henry VIII ordered every church to use one. The title page (opposite) shows the King presenting the Bible to the clergy and the people: a forceful message about royal supremacy.

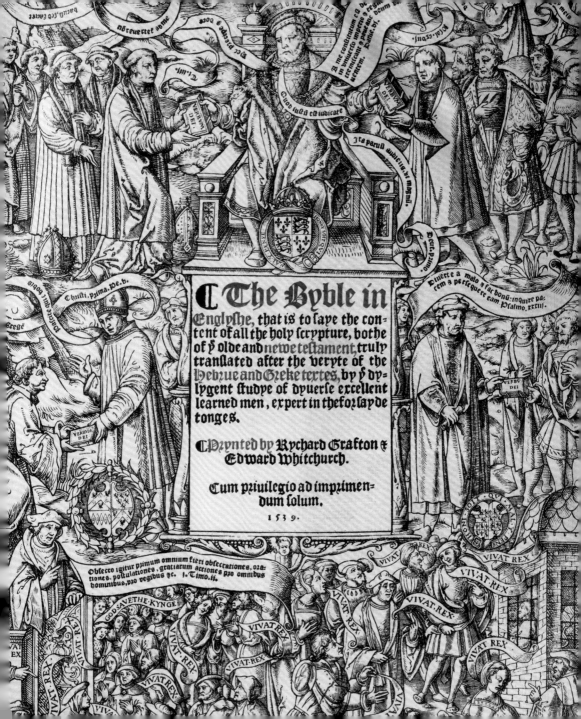

¶ The Byble in Englyshe, that is to saye the content of all the holy scrypture, bothe of ye olde and newe testament, truly translated after the veryte of the Hebrue and Greke textes, by ye dylygent studye of dyuerse excellent learned men, expert in the forsayde tonges.

¶ Prynted by Rychard Grafton & Edward Whitchurch.

Cum priuilegio ad imprimendum solum.

1539.

The Lyghfield Bible

LATE 13TH CENTURY

Enlarged detail from a pocket-sized Bible, which was owned by
William Lyghfield, a senior Canterbury monk, who had to leave
the monastery when it was closed in 1540. Lyghfield later received
a new, less important role with the Dean and Chapter. The detail is
of an initial F with a miniature of St Jerome at his desk. The initial
is at the beginning of the text of St Jerome's general prologue.

Purchased for Canterbury Cathedral with support from the National Heritage Memorial
Fund, the Friends of Canterbury Cathedral, the Friends of the National Libraries and a
private donation

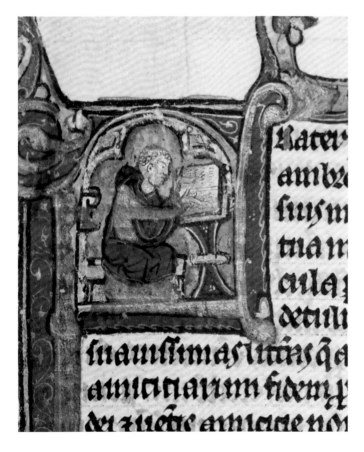

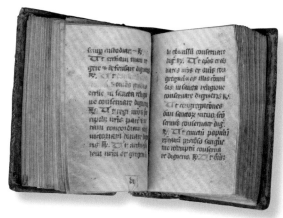

Monastic Psalter

14TH–15TH CENTURY

This tiny psalter (containing psalms and prayers) is only 8 cm high by 6 cm wide and 3.5 cm deep. It belonged to a monk from Christ Church Priory. After the Reformation it was censored to reflect new religious practices. Becket's name was erased from the list of saints as his cult was particularly targeted by Henry VIII.

The Golden Legend by Jacobus de Voragine

1493

This printed book is a collection of stories about saints, translated into English. It was a common religious text in the medieval period. After Henry VIII declared that Becket was not a saint in 1538, the stories about him in this copy were blacked out and partially removed.

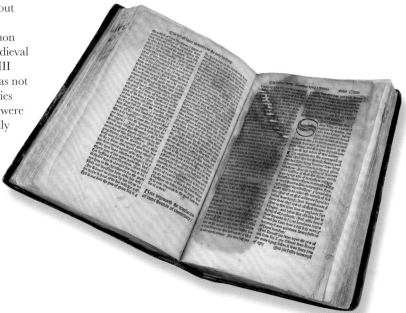

The Antiquities of Canterbury by William Somner

1640

This book about the historic treasures of Canterbury and the Cathedral was Somner's own copy and he made extensive notes in the margins. In 1643 Puritan clergyman Richard Culmer used a copy of the book to identify religious images within the Cathedral for destruction. The page shown here is an illustration of the Cathedral's font, installed in the 1630s.

Cathedrall Newes from Canterbury by Richard Culmer

1644

In this pamphlet Richard Culmer uses graphic language to describe his campaign of destruction at the Cathedral in 1643: '... *The worke is begun, the numerous Idols, which defile the worship of God there, are sweeping out apace.*'

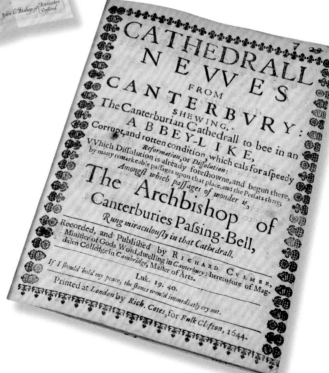

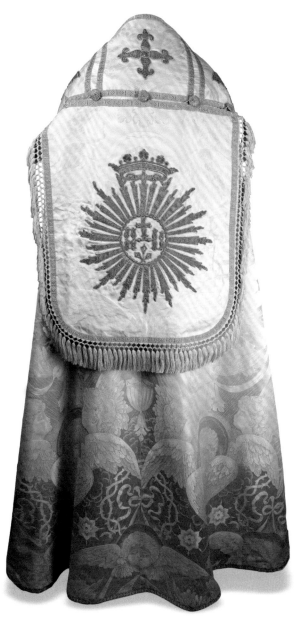

Cope and Mitre
1920s

These vestments were worn by Archbishop of Canterbury Cosmo Gordon Lang to perform the coronation of George VI. They are still used today by Canterbury's archbishops for special services.

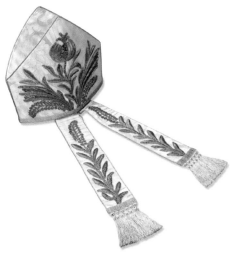

Faith and Power

While most of the objects in the Cathedral's collections
tell the story of the national and international impact of
Church–State relations from the viewpoint of the Church and
Cathedral, the perspective of the State is told through the
unique and beautiful funerary achievements of Edward, the
Black Prince. Held in the Cathedral for nearly 700 years, they
allow us to reflect upon his life as a national figure, as well as
on his piety and dedication to Canterbury Cathedral.

THE BLACK PRINCE'S ACHIEVEMENTS

MID- TO LATE 14TH CENTURY

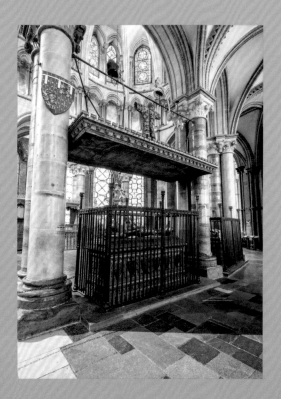

Edward Woodstock, often called the Black
Prince, was the eldest son and heir of King
Edward III. He died in 1376, leaving his son
Richard (later Richard II), then a child, as heir
to the throne.

Edward's tomb was placed close to Becket's
shrine. It is an elaborate monument, which
includes an effigy of the prince in full armour.
His funerary achievements (his armour, see the
following pages) were carried to the tomb during
his funeral procession and hung above it. Today,
replicas of the original achievements, made in
the 1950s, hang in place of the originals, which
are on display in the Crypt Exhibition.

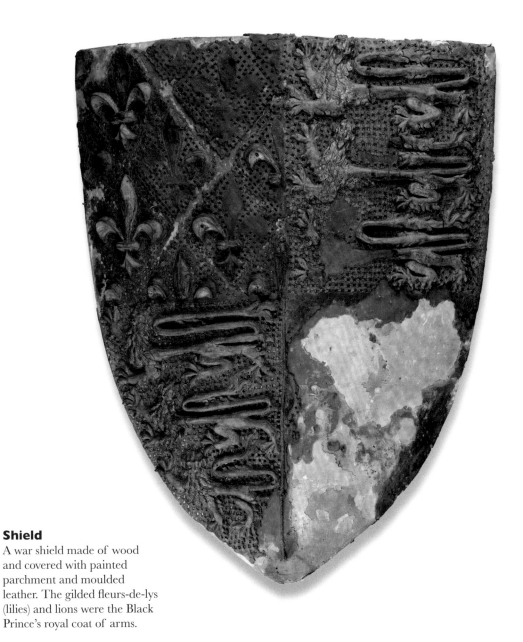

Shield

A war shield made of wood
and covered with painted
parchment and moulded
leather. The gilded fleurs-de-lys
(lilies) and lions were the Black
Prince's royal coat of arms.

Jupon

An armour coat of red and blue velvet, padded
with wool and lined with yellow silk. It is
embroidered in gold with lions and fleurs-de-lys,
the symbols of England and France respectively.

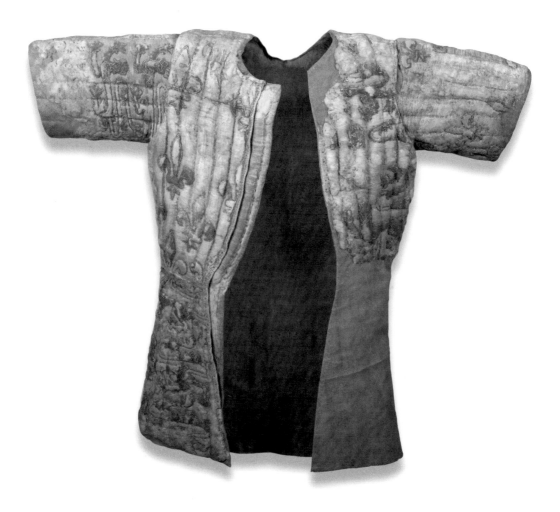

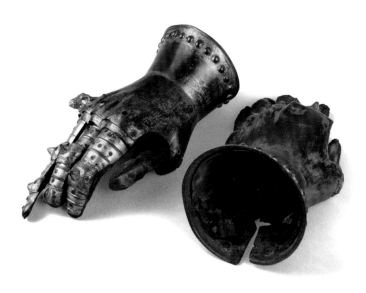

Gauntlets

These articulated gauntlets are made of copper gilt. The knuckles were originally decorated with gilded metal lions, only one of which remains, shown in the photograph below. The gauntlets are lined with buff leather gloves, which are extremely high-quality items, stitched with zigzag patterns down each finger, possibly in red silk.

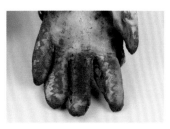

Belt Buckle

A belt buckle crafted into the shape of a lion's head.

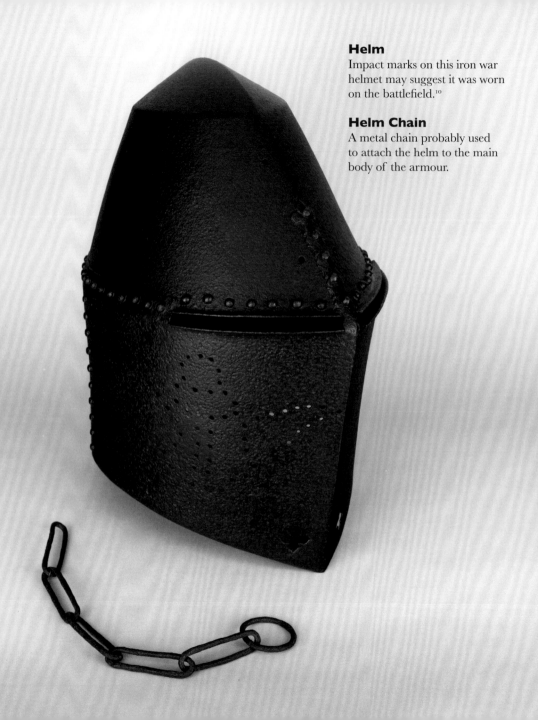

Helm
Impact marks on this iron war helmet may suggest it was worn on the battlefield.[10]

Helm Chain
A metal chain probably used to attach the helm to the main body of the armour.

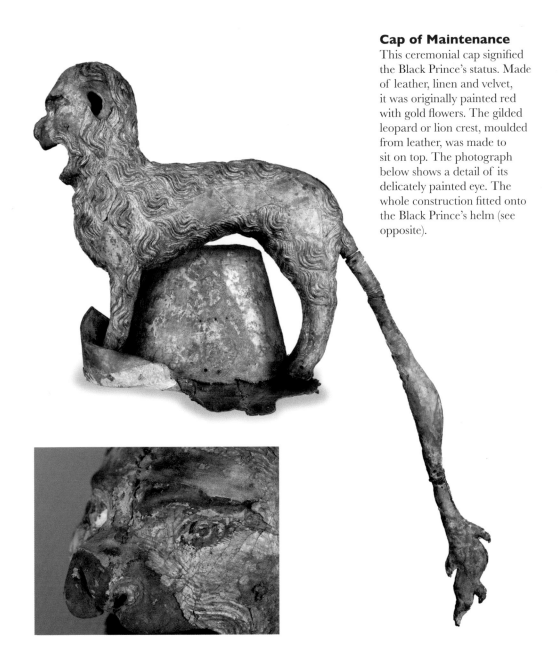

Cap of Maintenance

This ceremonial cap signified the Black Prince's status. Made of leather, linen and velvet, it was originally painted red with gold flowers. The gilded leopard or lion crest, moulded from leather, was made to sit on top. The photograph below shows a detail of its delicately painted eye. The whole construction fitted onto the Black Prince's helm (see opposite).

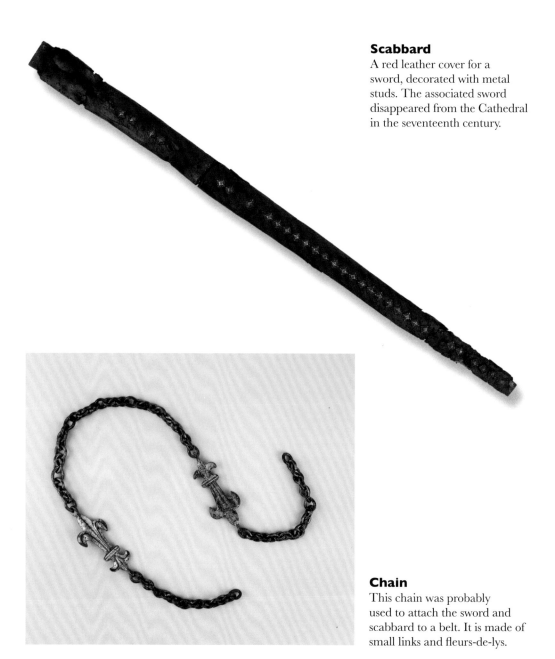

Scabbard

A red leather cover for a sword, decorated with metal studs. The associated sword disappeared from the Cathedral in the seventeenth century.

Chain

This chain was probably used to attach the sword and scabbard to a belt. It is made of small links and fleurs-de-lys.

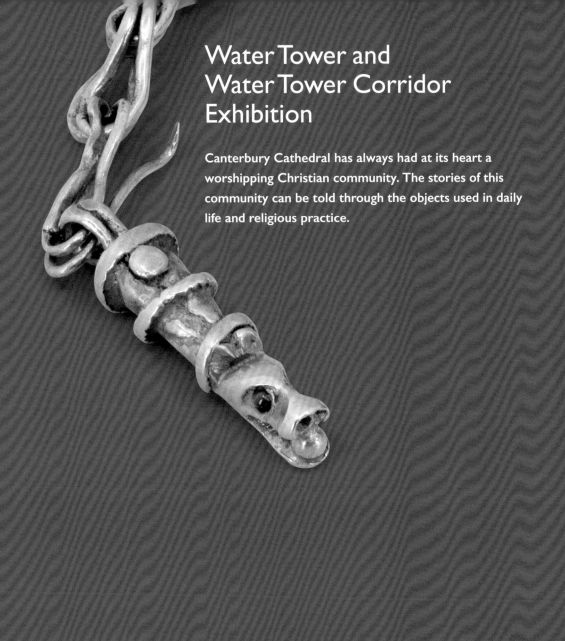

Water Tower and Water Tower Corridor Exhibition

Canterbury Cathedral has always had at its heart a worshipping Christian community. The stories of this community can be told through the objects used in daily life and religious practice.

Water Tower

Two small objects within the Cathedral's collections allow us to contemplate the rituals of a monastic life that ended in 1540 with the closure of Christ Church Priory. The objects, polar opposites in terms of quality, craftsmanship and cost (an elaborate Anglo-Saxon gold and silver sundial, and a bronze medieval stylus), signify the life of the monastery, its daily practices of worship (marked by the timepiece) and its creative output and learning (illustrated by the stylus).

Medieval Stylus
13TH–14TH CENTURY

This small stylus (11.9 cm long) may have been used for writing on a wax tablet or for ruling the page in the creation of manuscripts. It was found with a bundle of medieval documents under the floorboards of a room in the Cathedral in the 1860s.

Sundial and Gnomon

ABOUT 10TH CENTURY

A personal sundial, designed for telling the solar time in Canterbury. It is made from gold and silver and has two separate gold gnomons with serpent-shaped heads. The gnomon is a rod that creates the shadow allowing an individual to calculate the time of day. The sundial has two faces, one showing winter and autumn months, the other the spring and summer months. It is believed that this sundial was intended to calculate specific times of the monastic day. It was found during excavations of the Great Cloister in 1938.

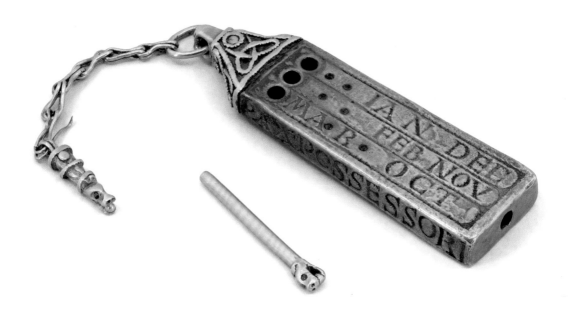

Water Tower Corridor

Church plate is an effective tool for exploring the changing nature of liturgy (an established form of public acts of worship) and practice within the Cathedral and parish churches.

Objects illustrated here are from the Cathedral's own collections as well as items loaned from parish churches in Kent.[11] There are representative examples of plate from the medieval, Reformation and Victorian periods.

Paten
1847
See page 60.

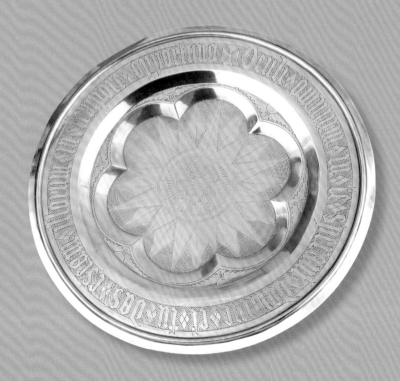

MEDIEVAL PLATE

Church plate in the medieval period was made from precious metal and was very decorative, as only the best was considered fit to be used during the Mass (the Christian service commemorating Christ's Last Supper, in which bread and wine are consecrated and consumed). Few pieces survived the upheaval of the sixteenth-century Reformation in England.

Chalice and Paten

MID- TO LATE 12TH CENTURY

A chalice is a cup used for wine during the Mass and a paten holds the bread. These silver-gilt examples were buried with Archbishop of Canterbury Hubert Walter and symbolise his role as a priest. They were found by his right hand when his tomb was opened in 1890 (see also Hubert Walter's vestments on pages 24–28). Both are worn and apparently well used.

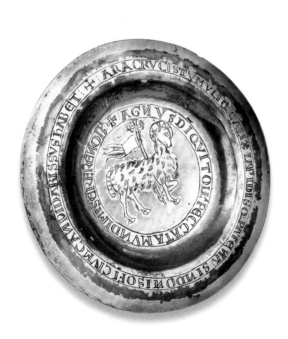

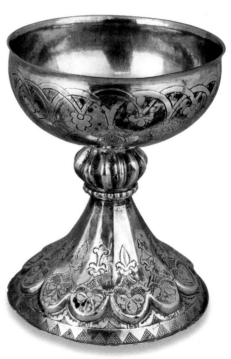

Chrismatory

1350–1400

This copper-alloy vessel held holy oils used in services such as baptisms and ordinations. It is a rare survival, as chrismatories were mostly destroyed during the Reformation. This was found in the roof space of St Martin's Church in the 1840s.

On loan from the Church of St Martin: Parish of St Martin and St Paul, Canterbury, Kent

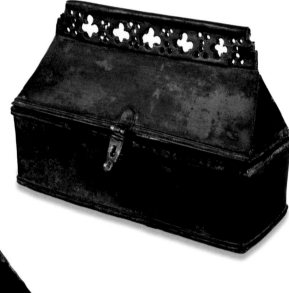

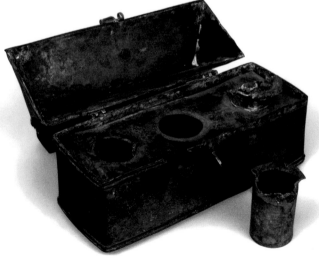

THE REFORMATION

In the 1560s and 1570s churches and cathedrals had to replace their fine medieval silverware with plain communion cups and patens. Although there is a consistency of form, silversmiths contributed their own individuality to the decoration of the vessels.

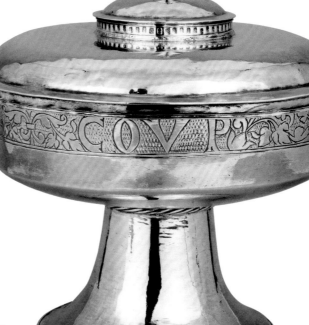

Cup

ABOUT 1525

This silver cup, sometimes known as a font cup or 'flatpece', and its lid were probably domestic items, later gifted to the Church of St Mary, Sandwich, for use in communion. The inscription in English, '*This is the comunion coup* [*sic*]', was added in the early 1550s in an identical script to that on a cup from neighbouring St Clement's Church (see page 52).

On loan from the Parish of St Clement, Sandwich, Kent

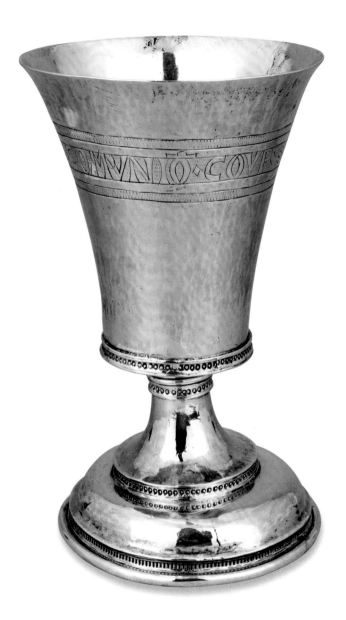

Communion Cup

ABOUT 1550

This very early communion cup
is made of silver and inscribed
in English: '*This is the communion
coup S Clemes* [*sic*]'. This simple
shape became the standard
design for such cups in the
sixteenth century.

On loan from the Parish of St Clement,
Sandwich, Kent

Communion Cup

1562

The cup has silver-gilt decoration, a thick stem and shallow bowl. It was made by French silversmith Robert Taylboyes, who worked in London.

On loan from the Parish of St Martin, Acrise and St Peter, Swingfield, Kent

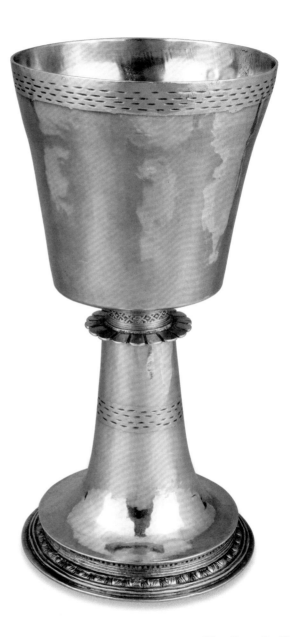

Communion Cup

ABOUT 1560–62

A typical silver cup, which was later inscribed with the name of the church and a date, '*St Alphege in Canterbury: June the First: 1714*'.

On loan from the Benefice of St Dunstan, St Mildred and St Peter, Canterbury, Kent

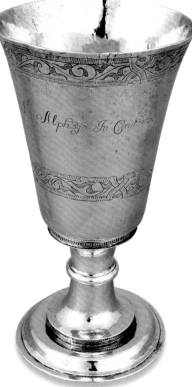

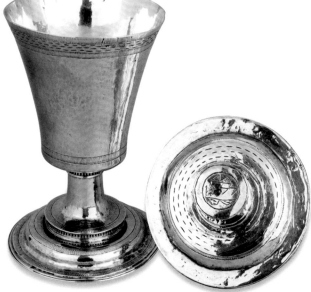

Communion Cup and Paten

1562 AND 1577

This cup dates from 1562. Its associated paten was not made until 1577.

On loan from the Parish of St Nicholas, Barfrestone, Kent

Communion Cup and Paten

1569

Silver cup and paten, with gilt decoration on the cup.

On loan from the Parish of Holy Cross, Bearsted, Kent

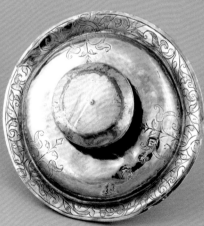

SEVENTEENTH-CENTURY CONFLICT

The seventeenth century saw the development of opposing forms of worship, with the monarchy and many bishops favouring ceremony and decoration while those known as 'Puritans' wanted simplicity. These tensions contributed to the English Civil Wars (1642–51) between Parliament and King.

Communion Cup
1635

This small silver cup (14.8 cm high), used in a local parish church, has no inscriptions and no decoration. Its size and simplicity reflect a 'Puritan' approach to worship.

On loan from the Church of St Mary, Kenardington, Kent: The Saxon Shoreline Benefice

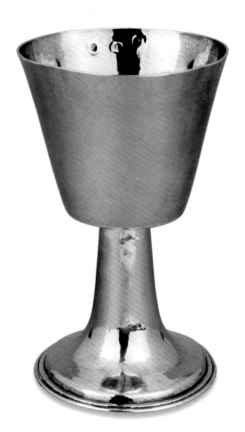

Lambeth Chalice and Paten

ABOUT 1635

This large silver-gilt chalice (24.6 cm high) and paten are of an elaborate style favoured by many bishops and the monarchy in the early seventeenth century.

On loan from Lambeth Palace, London

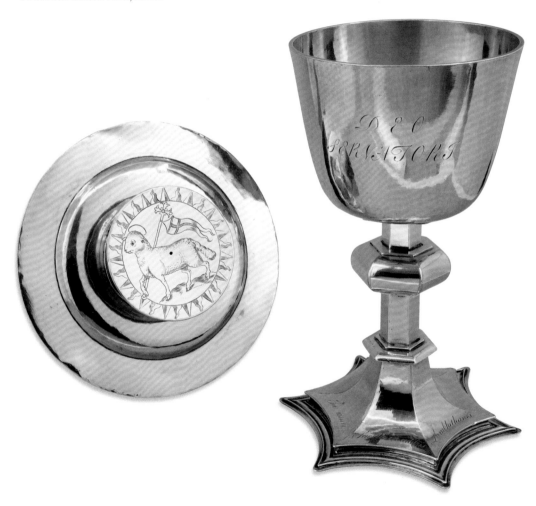

SECULAR GIVING

Gifting cups or plates to churches was common practice. The majority of gifts were originally domestic, later adapted for church use. They frequently commemorated the giver or emphasised the donor's importance in the community.

Flagon

1591–92

Flagons were used to hold additional wine for the congregation. This silver-gilt example was gifted to the church once its style was becoming unfashionable in domestic use.

On loan from the Parish of All Saints, Biddenden, Kent

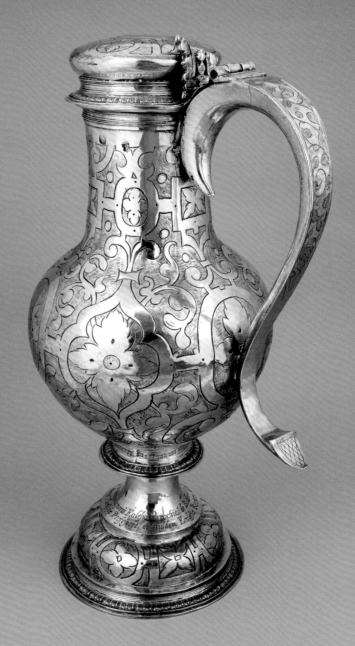

Steeple Cup and Lid

1600

This large silver-gilt vessel stands at 49 cm tall when the lid is on the cup. It is called a steeple cup because of its height and pinnacle-shaped lid. Originally made for display on a dining table, the inscription states, '*Given for the use of the communion table*'.

On loan from the Church of St Peter and St Paul, Charing, Kent: The G7 Benefice

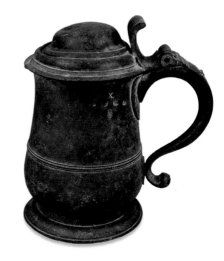

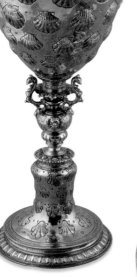

Flagon

ABOUT 1728

A pewter tankard of a type also used in local inns.

On loan from the Church of St Augustine, Snave, Kent: The Saxon Shoreline Benefice

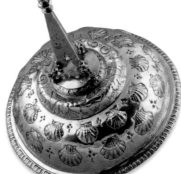

THE VICTORIAN CHURCH

In the 'High Church' revival of the Victorian period, the way worship was conducted, and the objects and architecture associated with worship, were dramatically transformed. A new style known as 'Gothic Revival' reintroduced medieval design into art and architecture, emulating Gothic motifs with high spires and ornate, intricate designs.

Chalice and Paten

1847

These silver-gilt objects, designed by architect William Butterfield, are of the nineteenth-century 'Gothic Revival' style.

On loan from the Trustees of the
St Augustine's Foundation, Canterbury, Kent

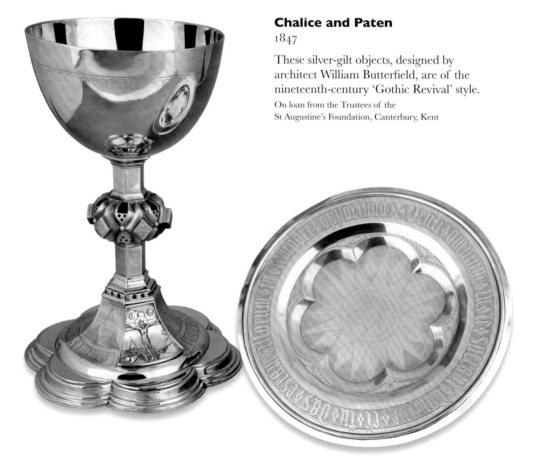

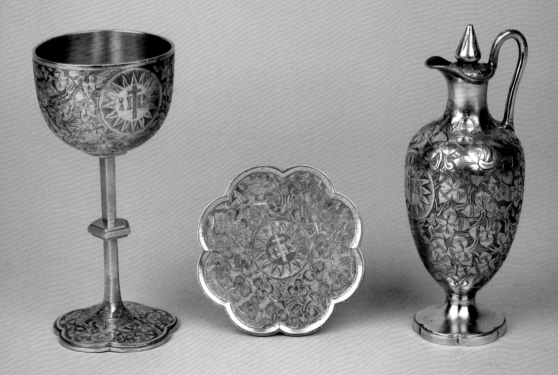

Portable Communion Set
1842

A small 'Gothic Revival' silver-gilt chalice, paten and flagon used to give communion at locations other than the church. The chalice is only 12 cm high.

Notes

1 All information about the collections is accurate at the time of publication.
2 E. Oakley quoted in De Moubray, A. 'Lowly communion', *The World of Interiors* (April 2011), pp. 51–54, p. 53.
3 With thanks to Ana Cabrera Lafuente, Dpto de Colecciones – Museo del Traje, Madrid, for her insight into these textiles.
4 Personal communication 2018. Ana Cabrera Lafuente, Dpto de Colecciones – Museo del Traje, Madrid.
5 Ibid.
6 Kjølbye-Biddle, B. 'Specialist reports: two Anglo-Saxon relief-decorated floor tiles', in K. Blockley, M. Sparks and T. Tatton-Brown (eds). *Canterbury Cathedral Nave: Archaeology, History and Architecture* (Canterbury: Dean and Chapter of Canterbury and Canterbury Archaeological Trust, 1997), pp. 196–200.
7 Personal communication 2020. Dr Amy Jeffs, Paul Mellon Centre Postdoctoral Fellow and Colin Torode, Independent Researcher.
8 Hope, W.H. St John. 'On the tomb of an archbishop recently opened in the Cathedral Church of Canterbury', *Vetusta Monumenta*, volume VII, part I (Westminster: Society of Antiquaries of London; Nichols and Sons, 1893).
9 Muthesius, A. 'The silks from the tomb [of Archbishop Walter]', *Medieval Art and Architecture at Canterbury before 1200*, The British Archaeological Association, Conference Transactions for the Year 1979, vol. 5 (Leeds, 1982), pp. 80–87.
10 Personal communication 2017. Alan Williams, Archaeo-metallurgist, Conservation Department, The Wallace Collection, London. Neutron diffraction studies have shown that the metal has been strained by impact (probably in battle), although there are not now any visible marks on the surface. The plate was evidently straightened without reheating.
11 With thanks to Dr Timothy Schroder for information and advice about the church plate held at the Cathedral.

Acknowledgements

With thanks to all the staff and volunteers at Canterbury Cathedral. Special thanks must also be given to all those experts at universities and museums who have offered their help with and advice about the interpretation of the collections. There are too many others to mention who have illuminated our understanding of the Cathedral's precious objects, but you know who you are – thank you.

References for Archives Documents

Grant from Offa, King of Mercia (page 10)
788
Collections reference:
CCA-DCc/ChAnt/M/340

Decree of the Synod of Clofesho (page 11)
12 October 803
Collections reference:
CCA-DCc/ChAnt/C/1

The Accord of Winchester (page 14)
1072
Collections reference:
CCA-DCc/ChAnt/A/2

Seal of Anselm, Archbishop of Canterbury
(with seal) (page 15)
1095–1107
Collections reference:
CCA-DCc/ChAnt/C/1193

Canterbury Passional (page 17)
Early 12th century
Collections reference:
CCA-DCc-LitMs/E/42

Grant from William de Tracy (page 19)
About 1174
Collections reference:
CCA-DCc/ChAnt/D/20

Writ from Henry II (page 20)
About 1175
Collections reference:
CCA-DCc/ChAnt/C/19

Mandate from Pope Innocent III (page 29)
December 1205
Collections reference:
CCA-DCc/ChAnt/A/187

Grant from King John (page 29)
4 April 1206
Collections reference:
CCA-DCc/ChAnt/O/117

Guarantee (page 30)
24 May 1213
Collections reference:
CCA-DCc/ChAnt/C/254

Grant from King John (page 31)
21 November 1214
Collections reference:
CCA-DCc/ChAnt/C/109

This edition © Scala Arts & Heritage Publishers Ltd, 2020

Text © The Chapter of Canterbury, 2020
Photographs © The Chapter of Canterbury, 2020

First published in 2020 by
Scala Arts & Heritage Publishers Ltd
10 Lion Yard, Tremadoc Road, London sw4 7nq
www.scalapublishers.com

In association with Cathedral Enterprises Limited
The Chapter of Canterbury
Canterbury Cathedral
Cathedral House, 11 The Precincts, Canterbury ct1 2eh
www.canterbury-cathedral.org

ISBN 978-1-78551-264-3

Compiled by Dr Sarah Turner
Photography: Adrian C. Smith
Project manager and copy editor: Linda Schofield
Designer: James Alexander at Jade Design
Printed and bound in Turkey

10 9 8 7 6 5 4 3 2 1

Front cover: Chalice, mid- to late 12th
century (see page 49).
Back cover: The Great Bible, 1539
(see page 33).
Front cover flap: Sundial and Gnomon,
about 10th century (see page 47).
Inside cover (front and back): Scenes from
Canterbury Cathedral's history. Artwork
by Katie Ponder, © The Chapter of
Canterbury
Page 1: Detail of the silk from the cope of
Cosmo Lang, 1920s (see page 37).
Page 2: Detail of an illuminated letter
from the Canterbury Passional, early 12th
century (see page 17).
Pages 4–5: Detail of the crosses made
by William the Conqueror and Queen
Matilda to witness the 1072 Accord of
Winchester (see page 14).